Copyright © 2017 Dea Bernadette D. Suselo
All rights reserved.

ISBN: 1-6762-6195-8

www.facebook.com/DeaBernadette
Instagram: dea_bernadette

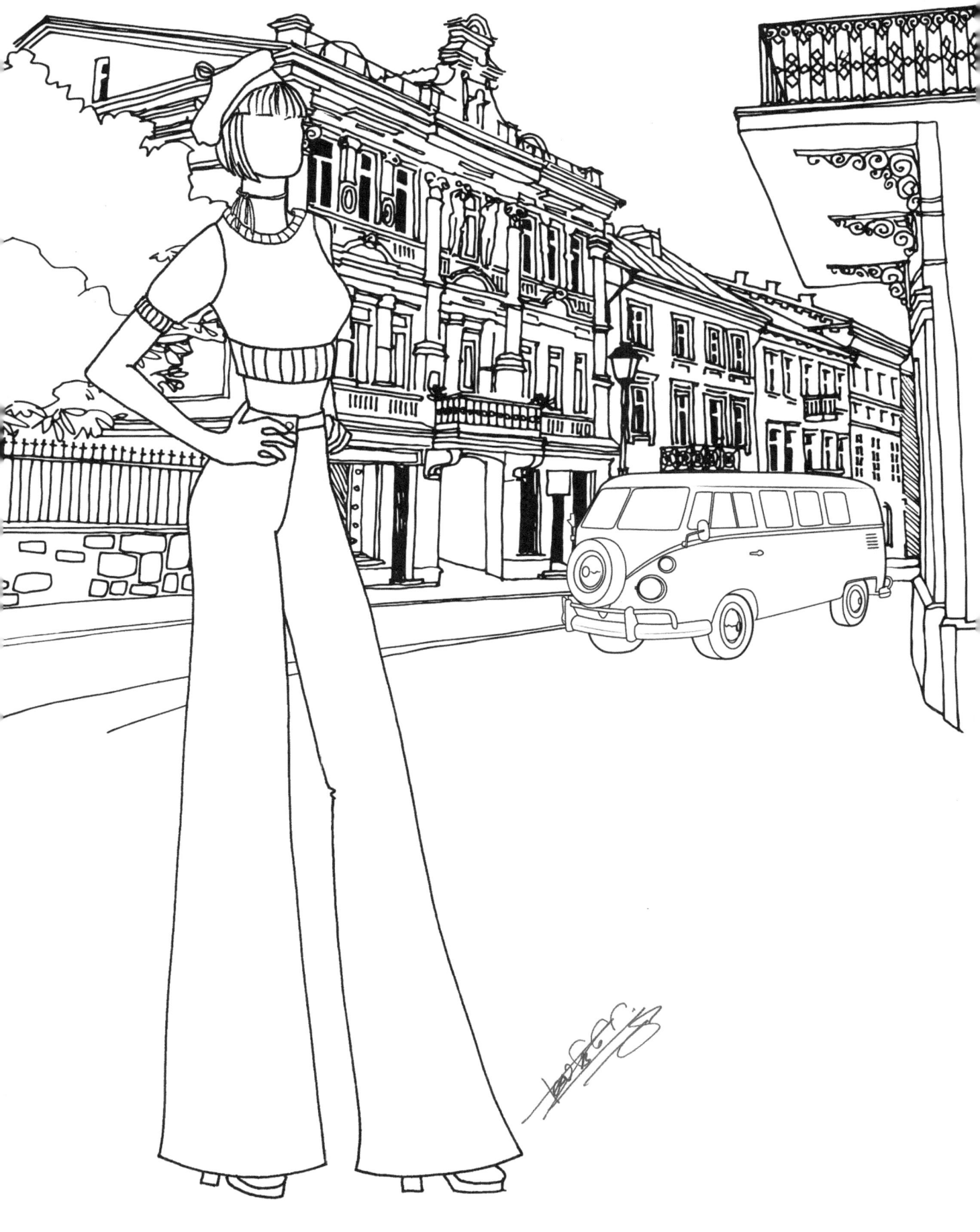

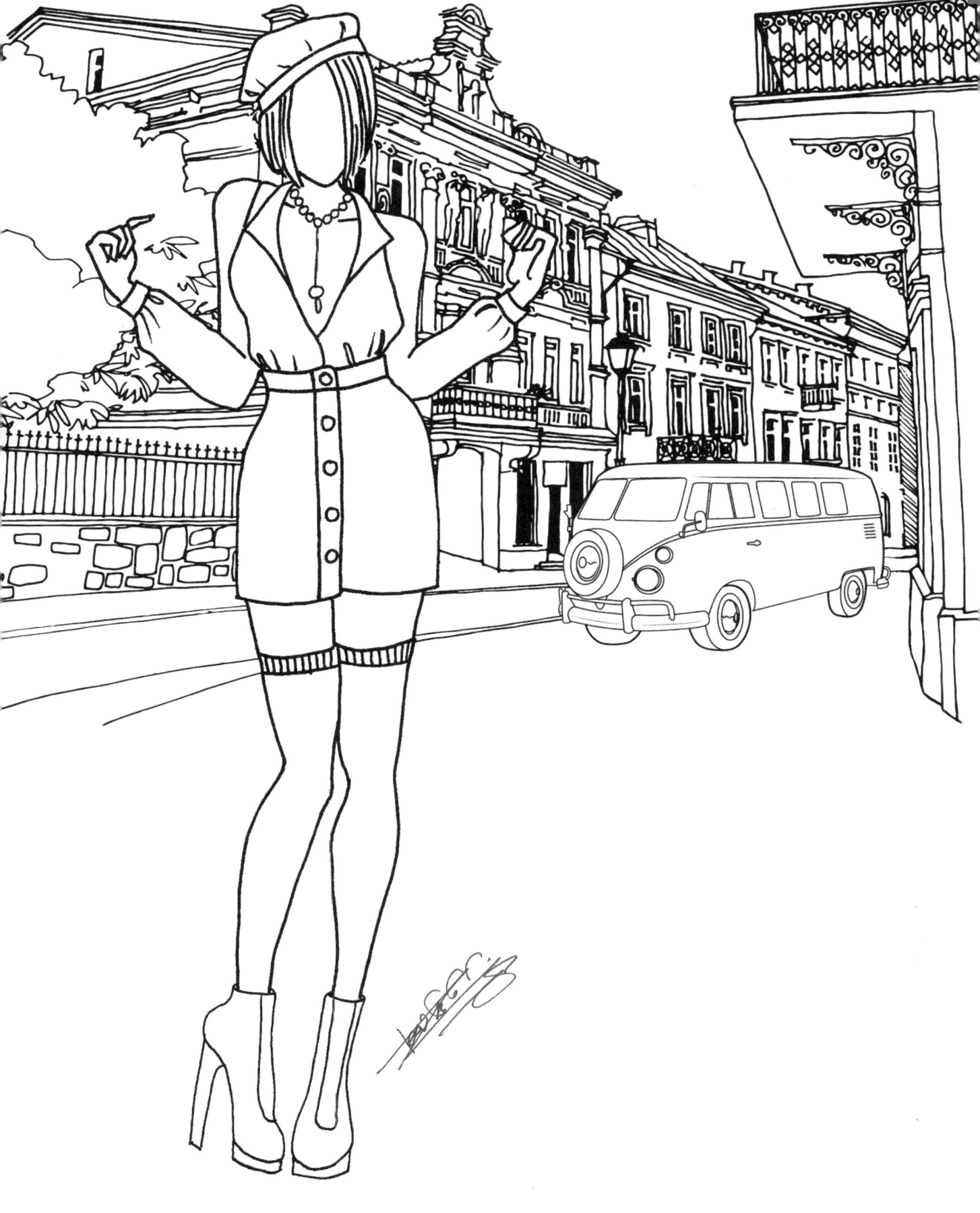

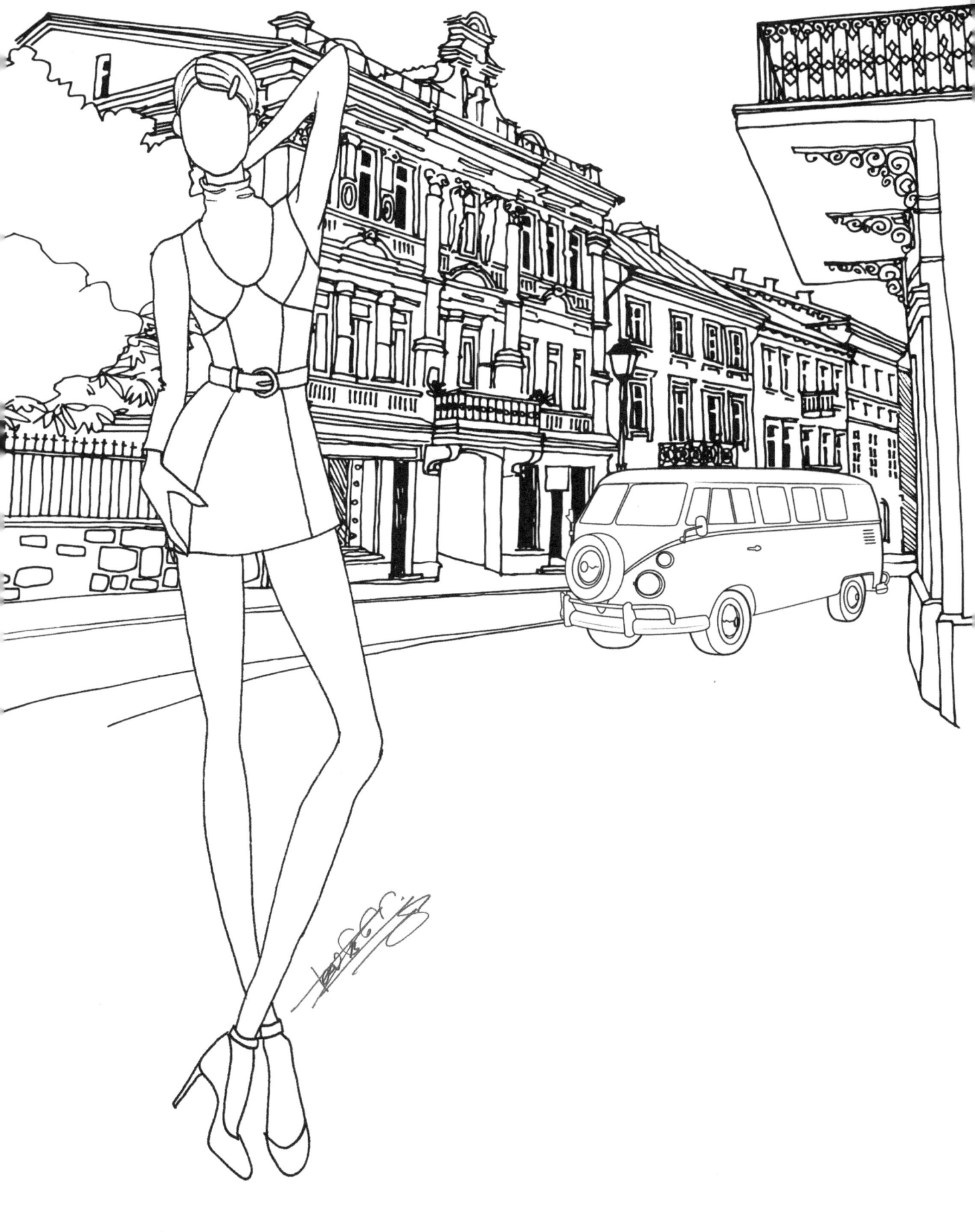

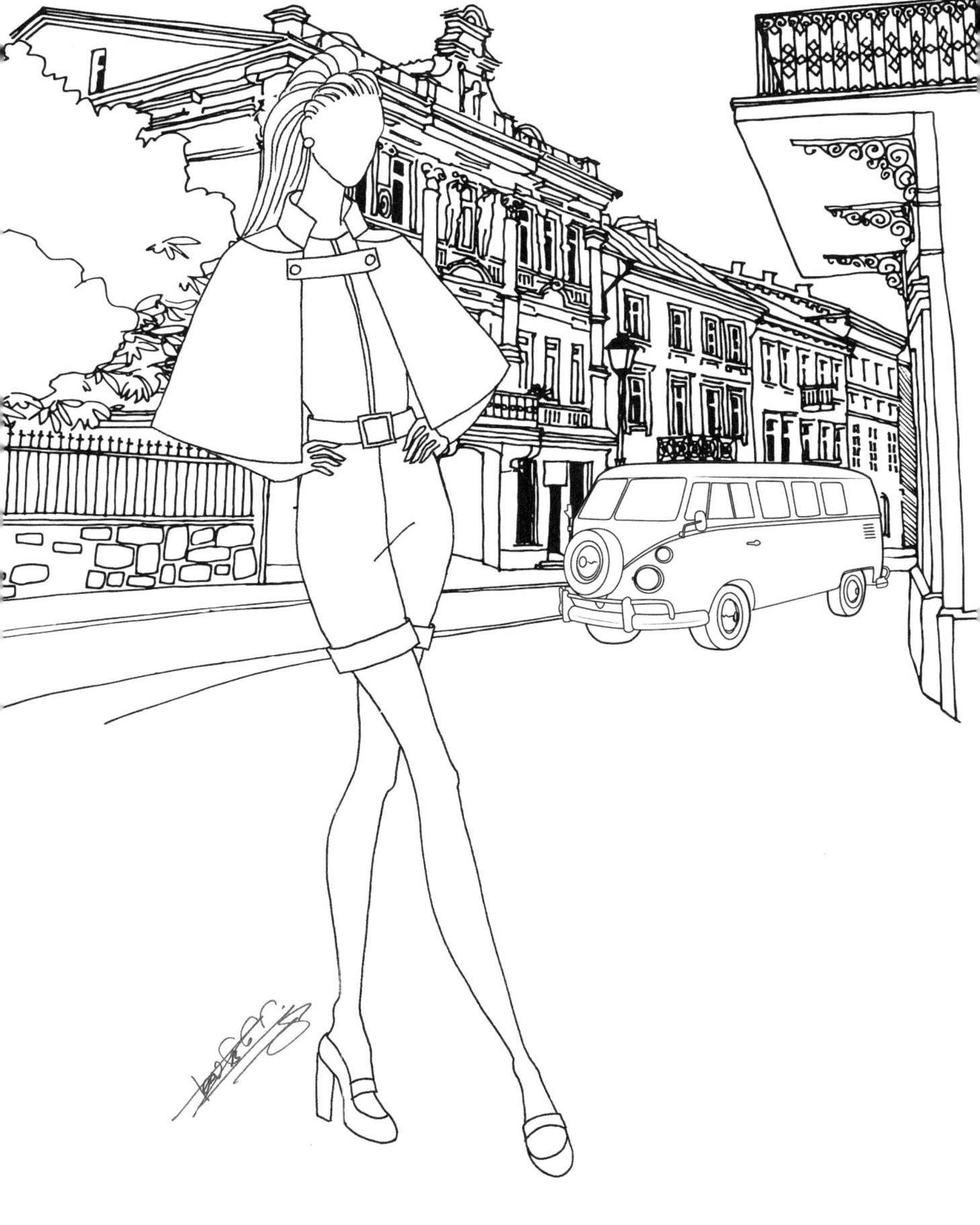

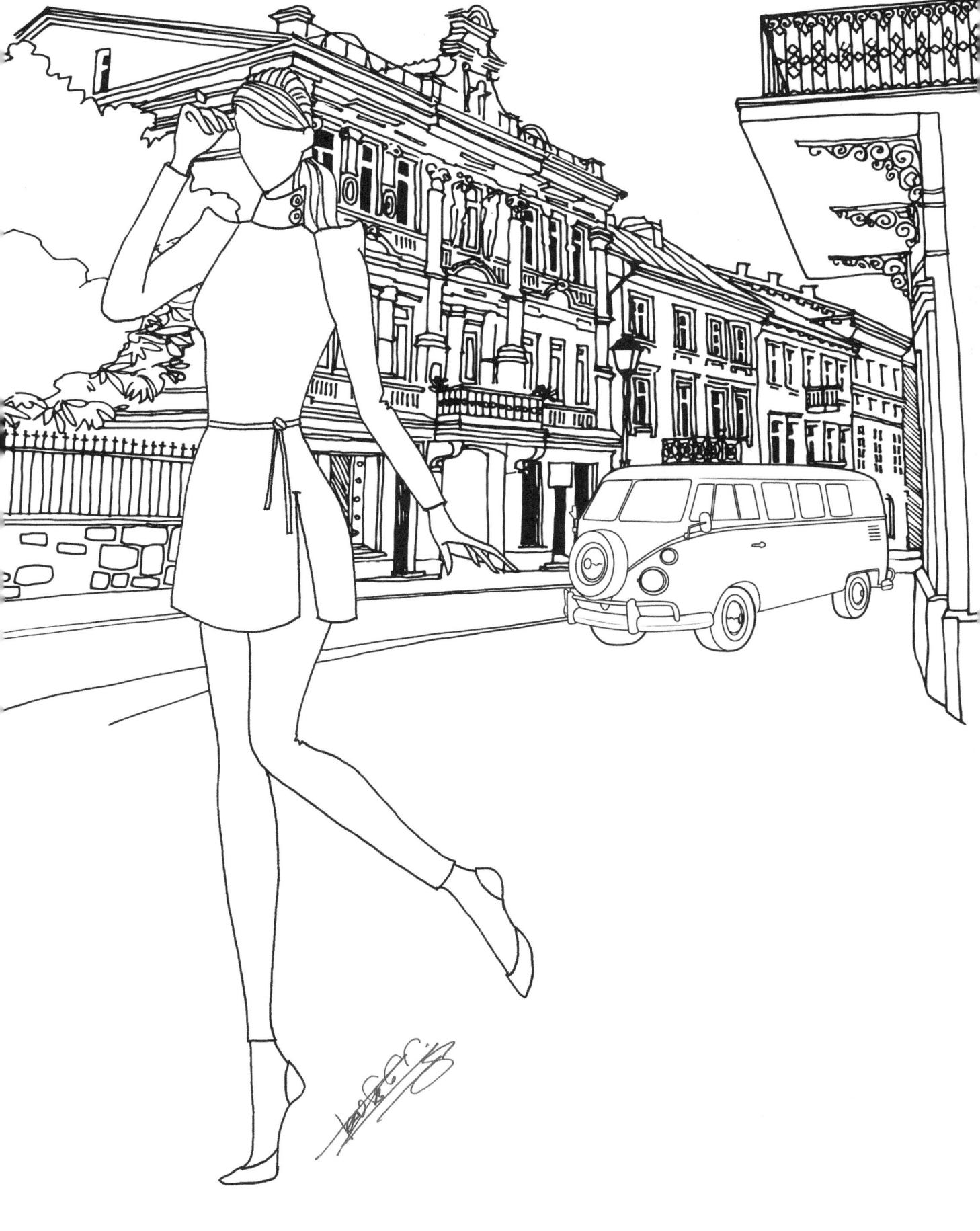

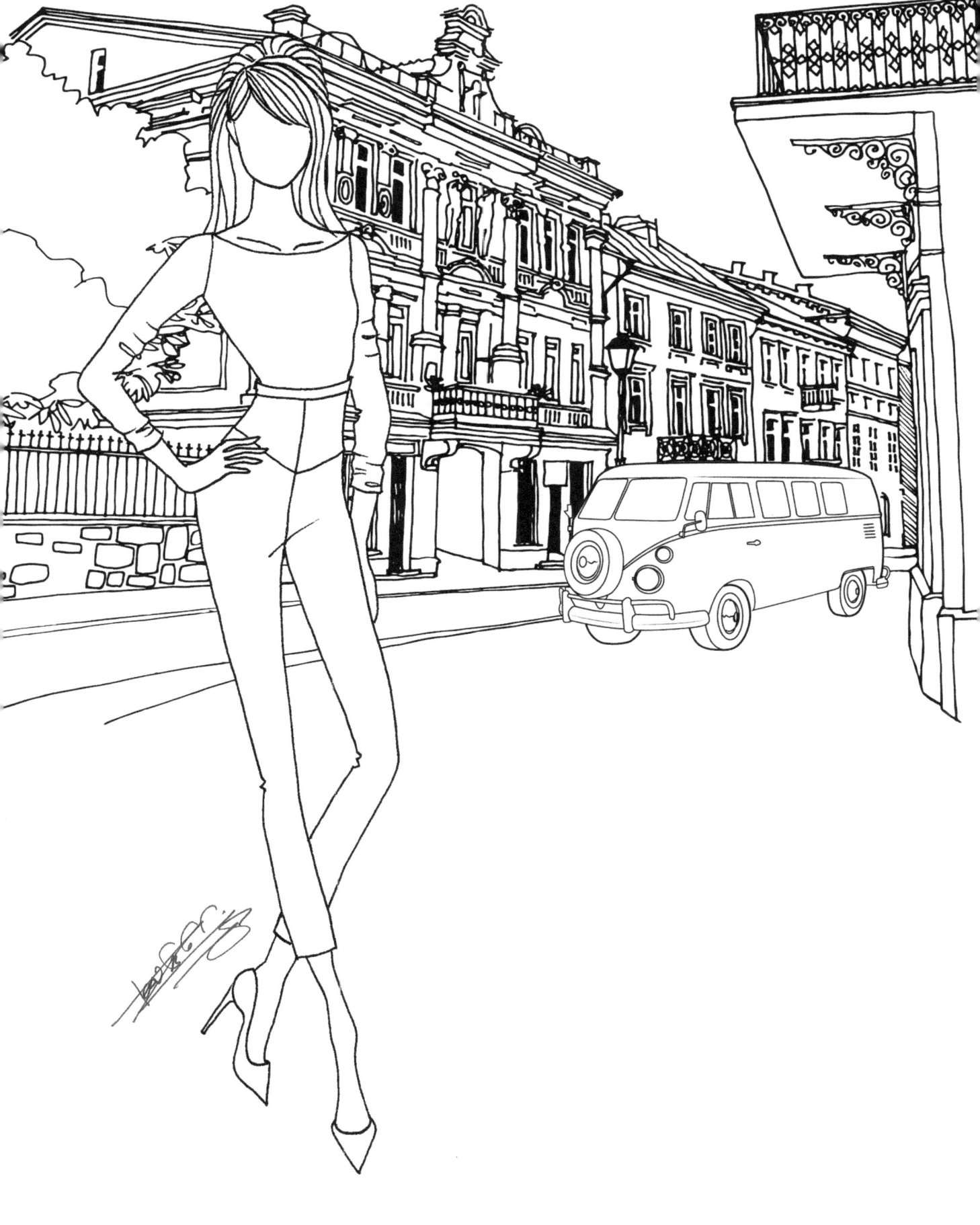

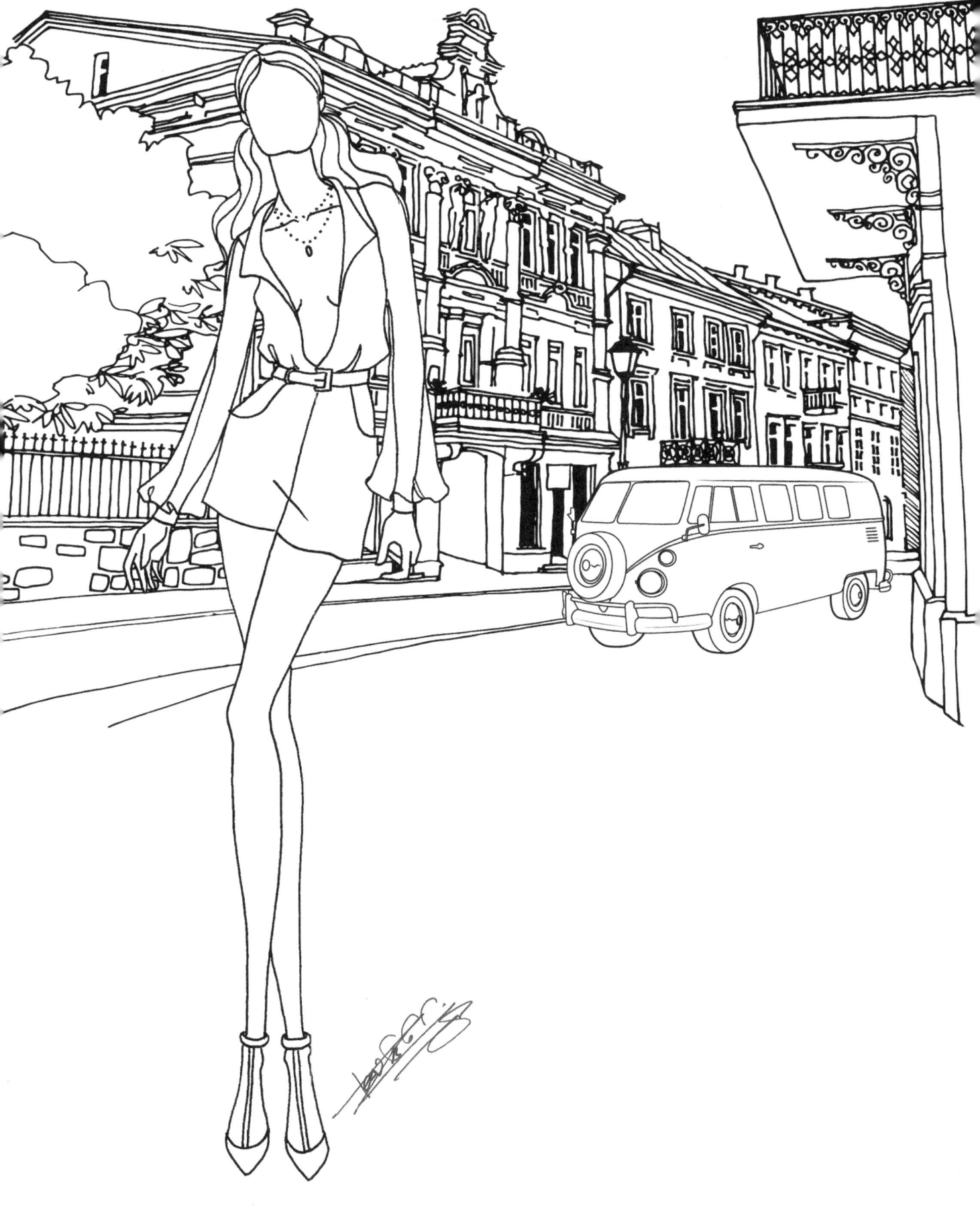

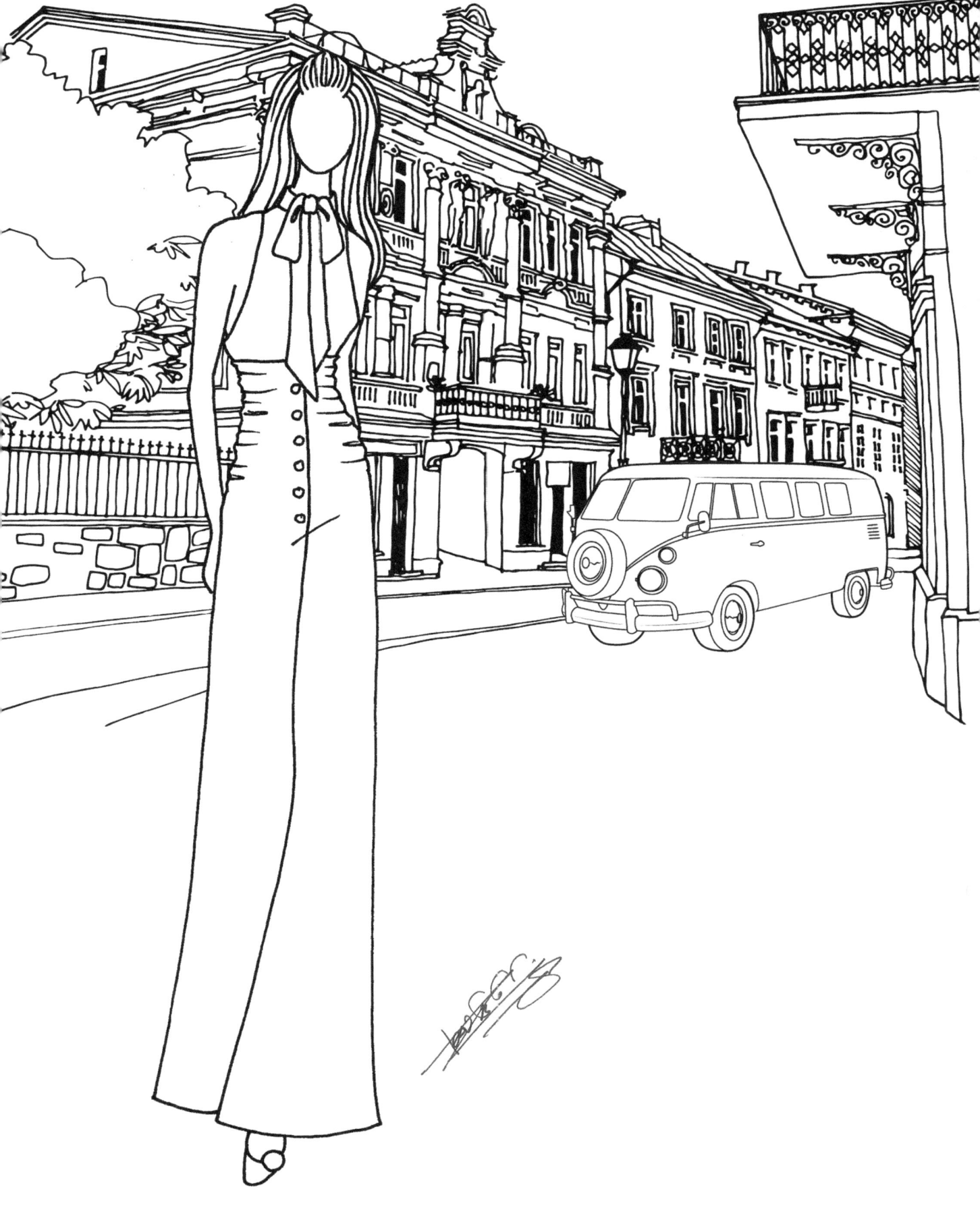

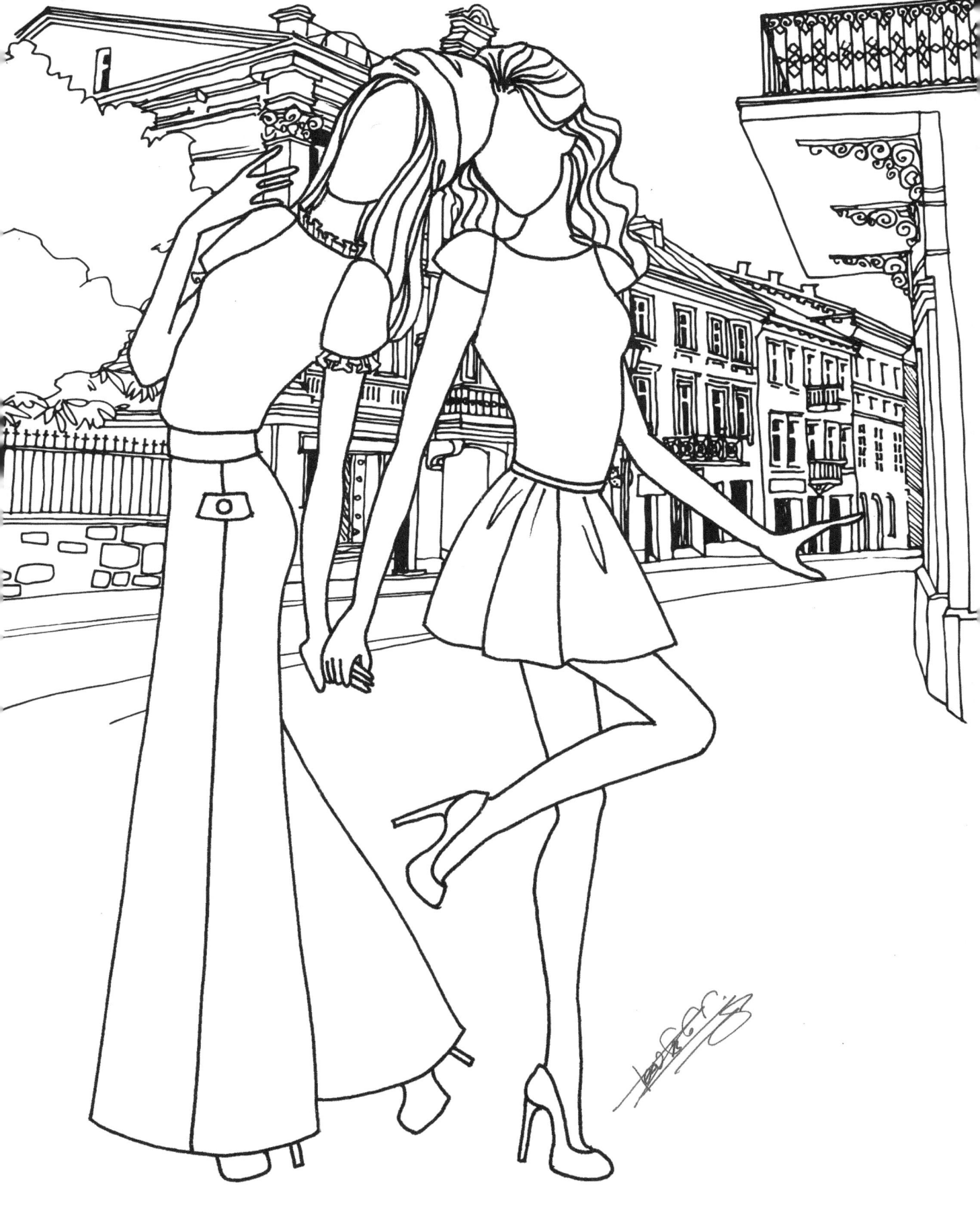

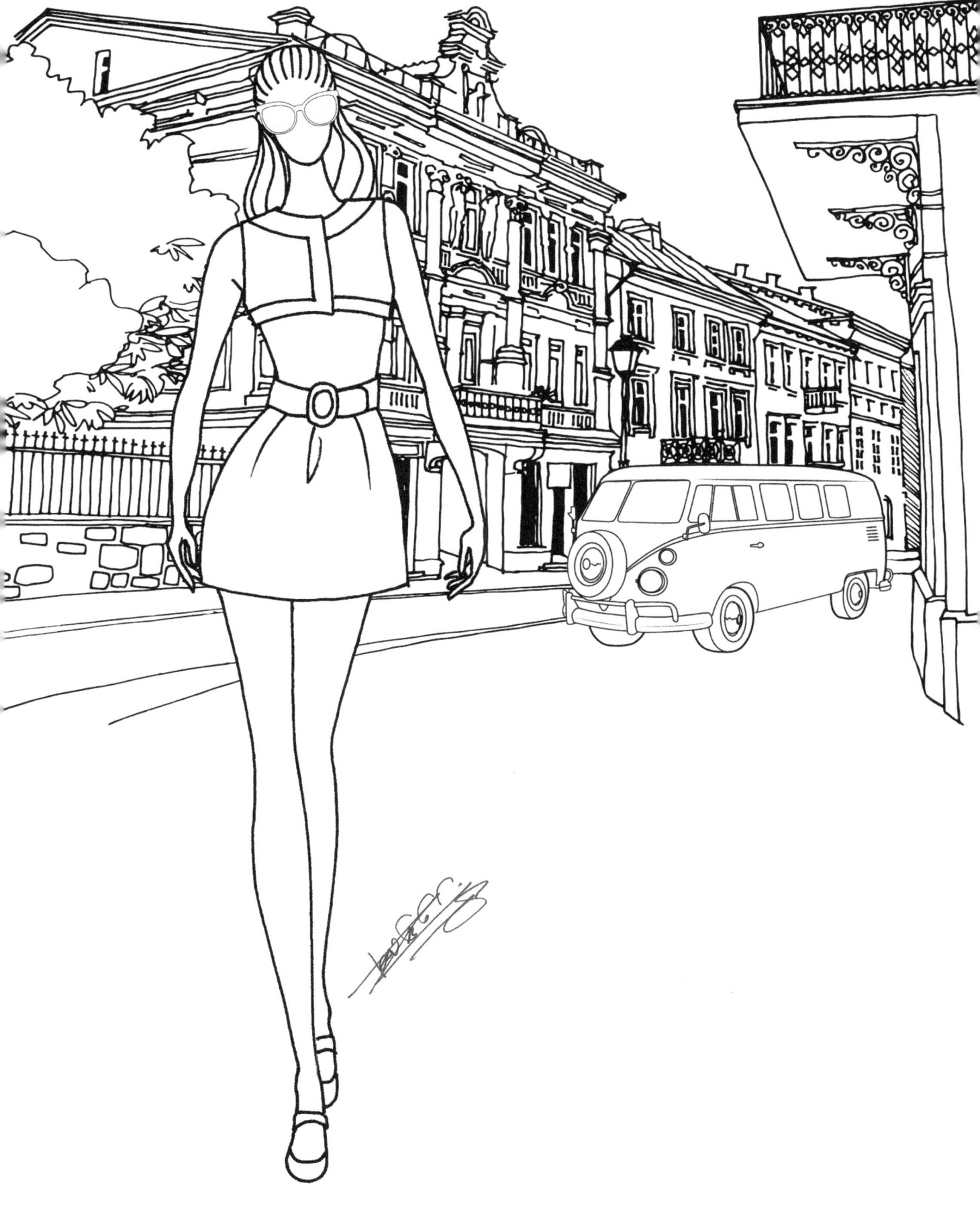

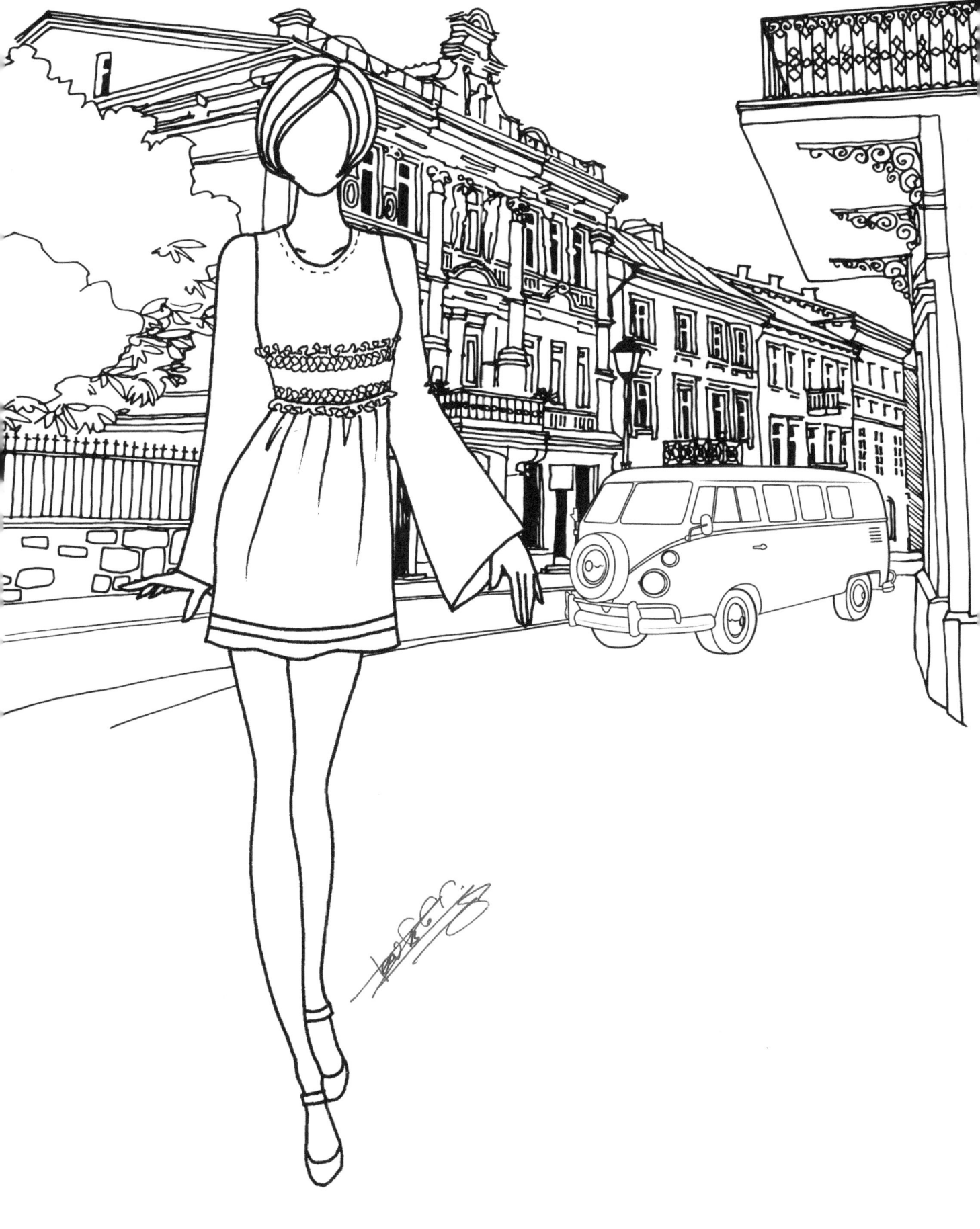

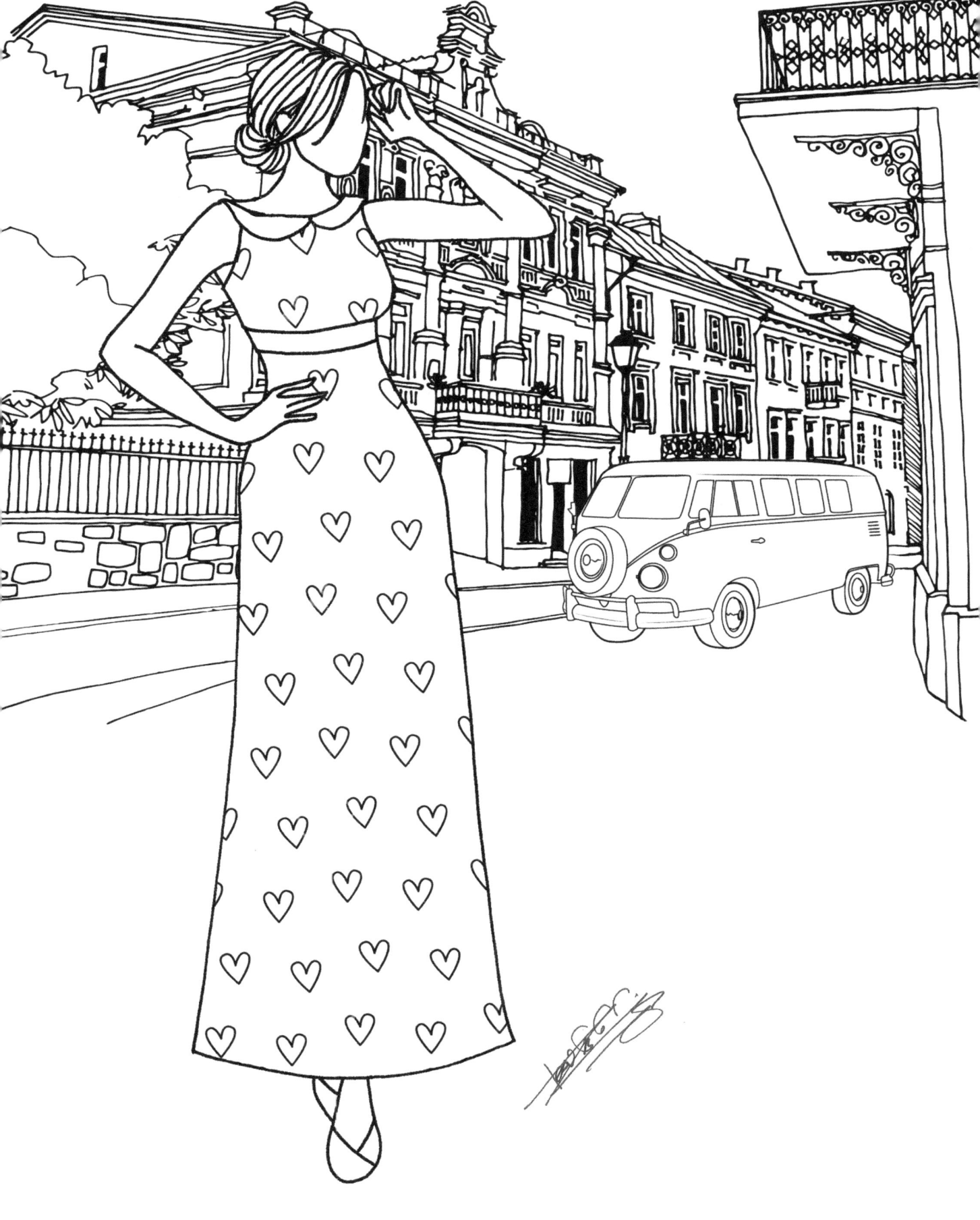

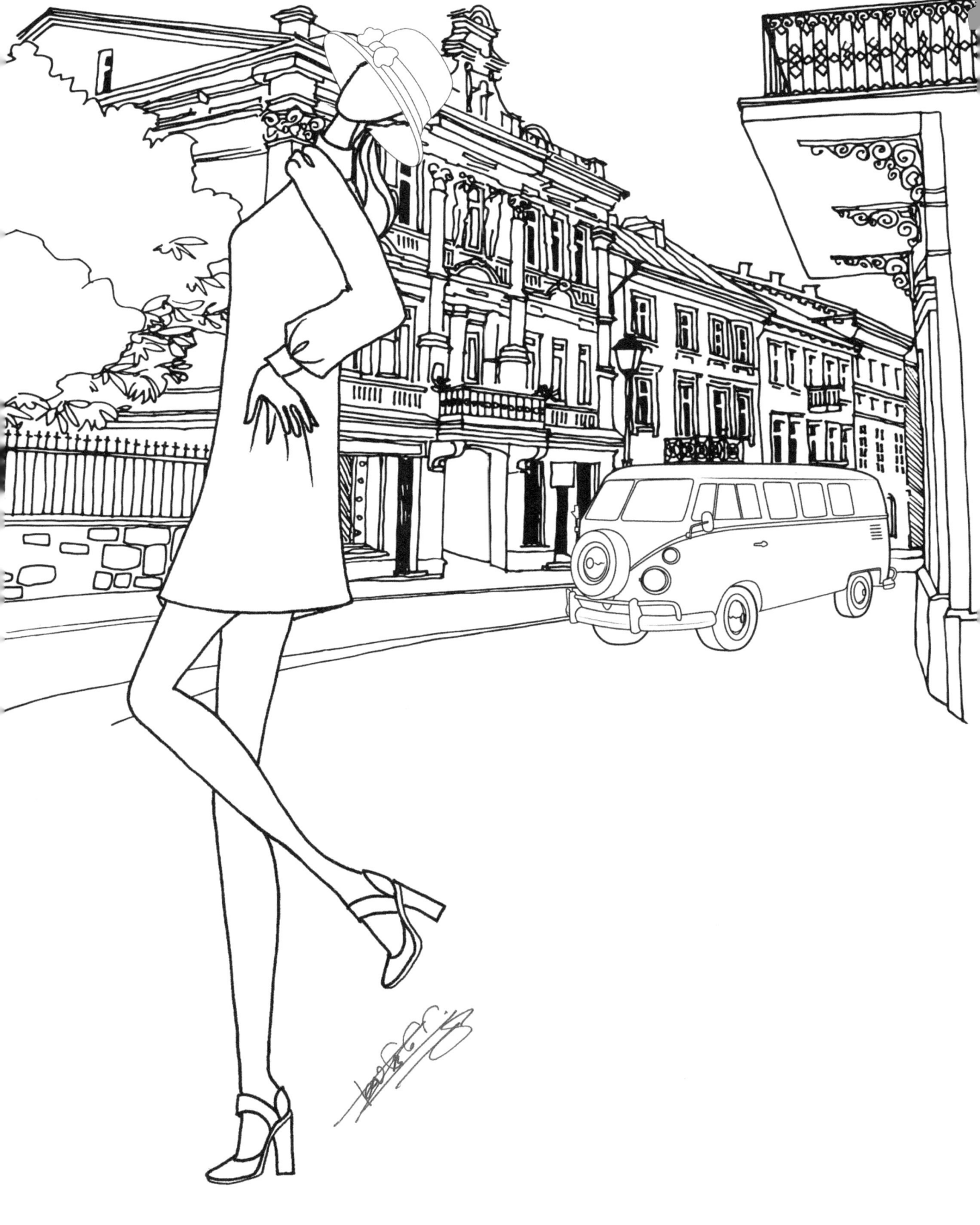

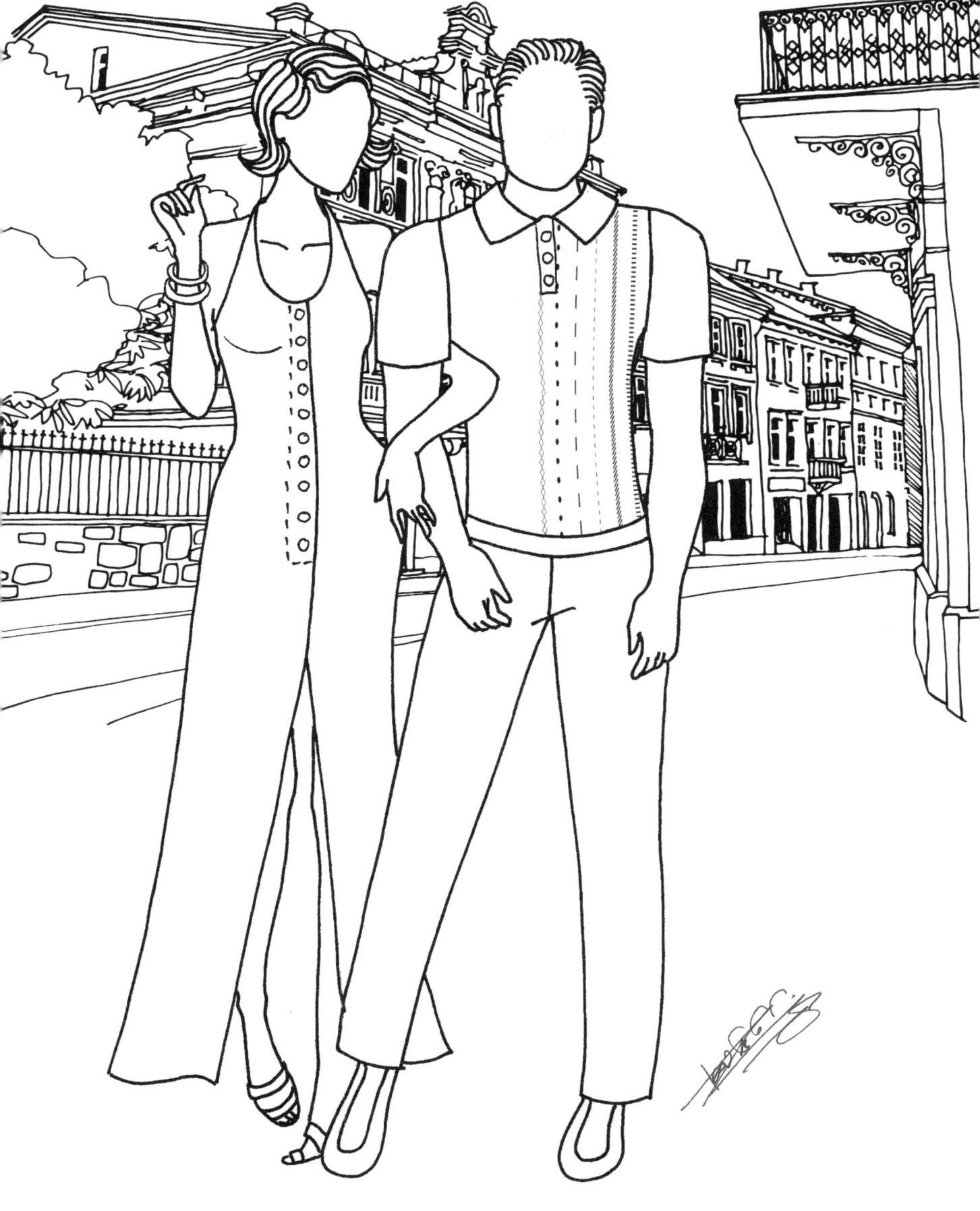

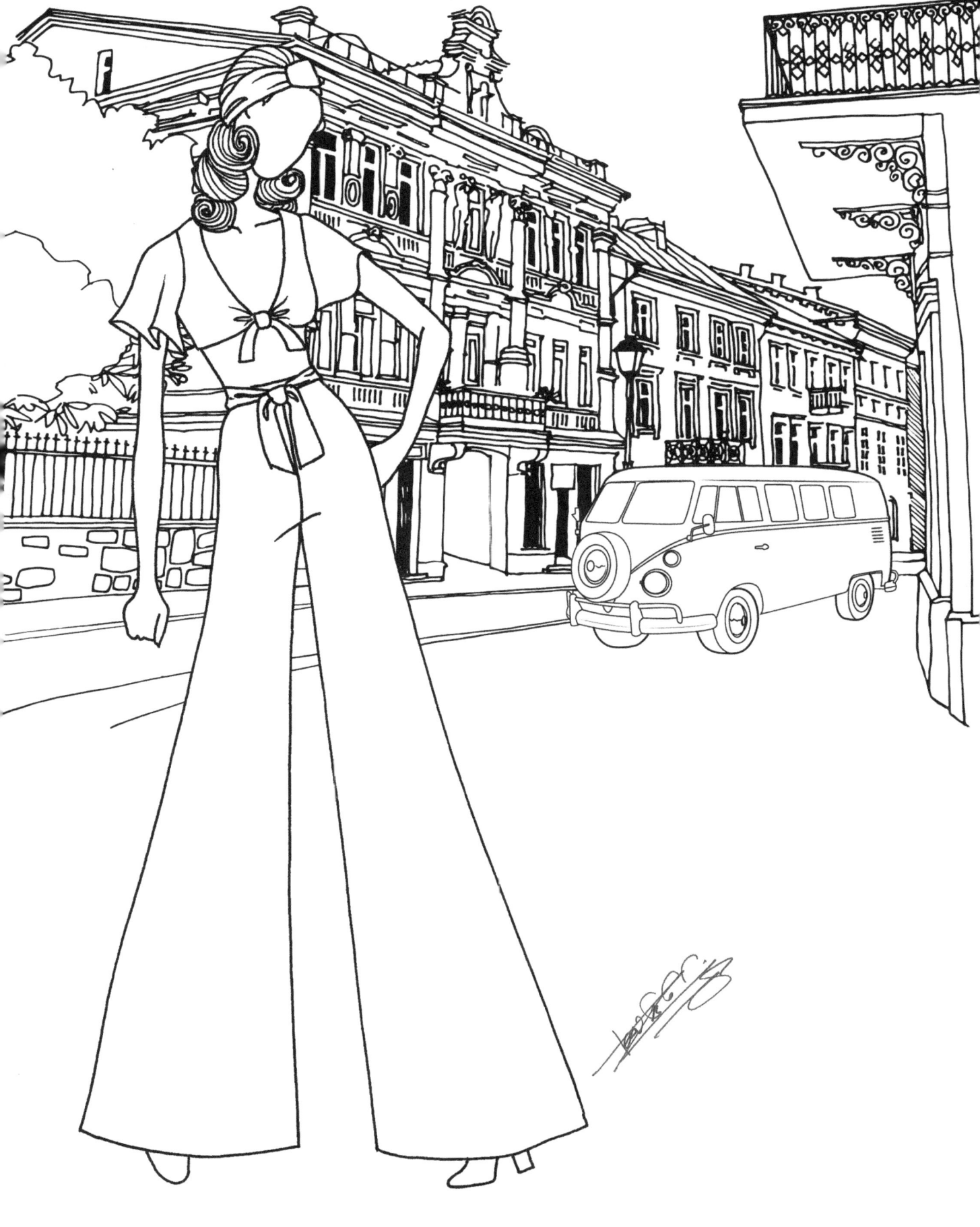

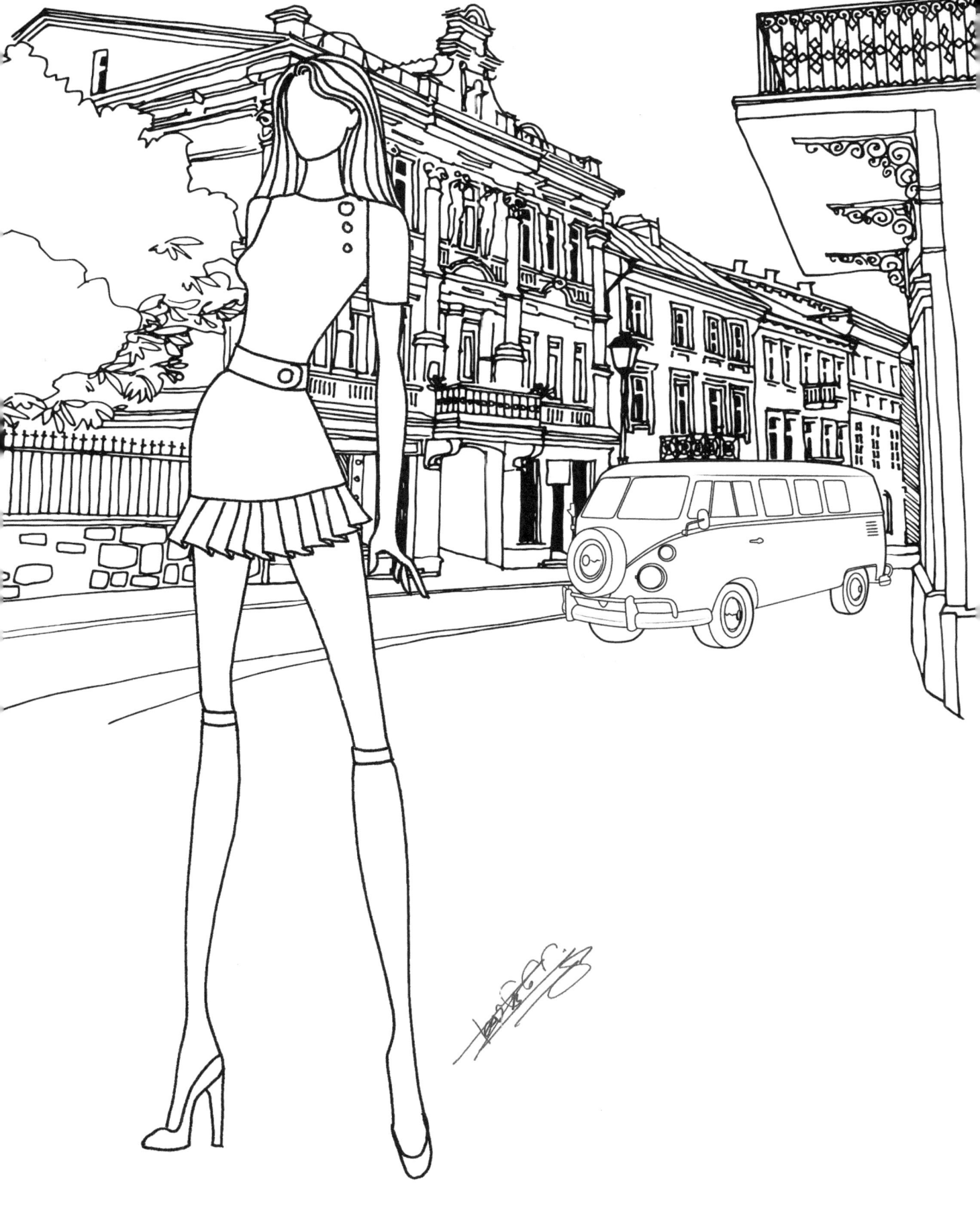

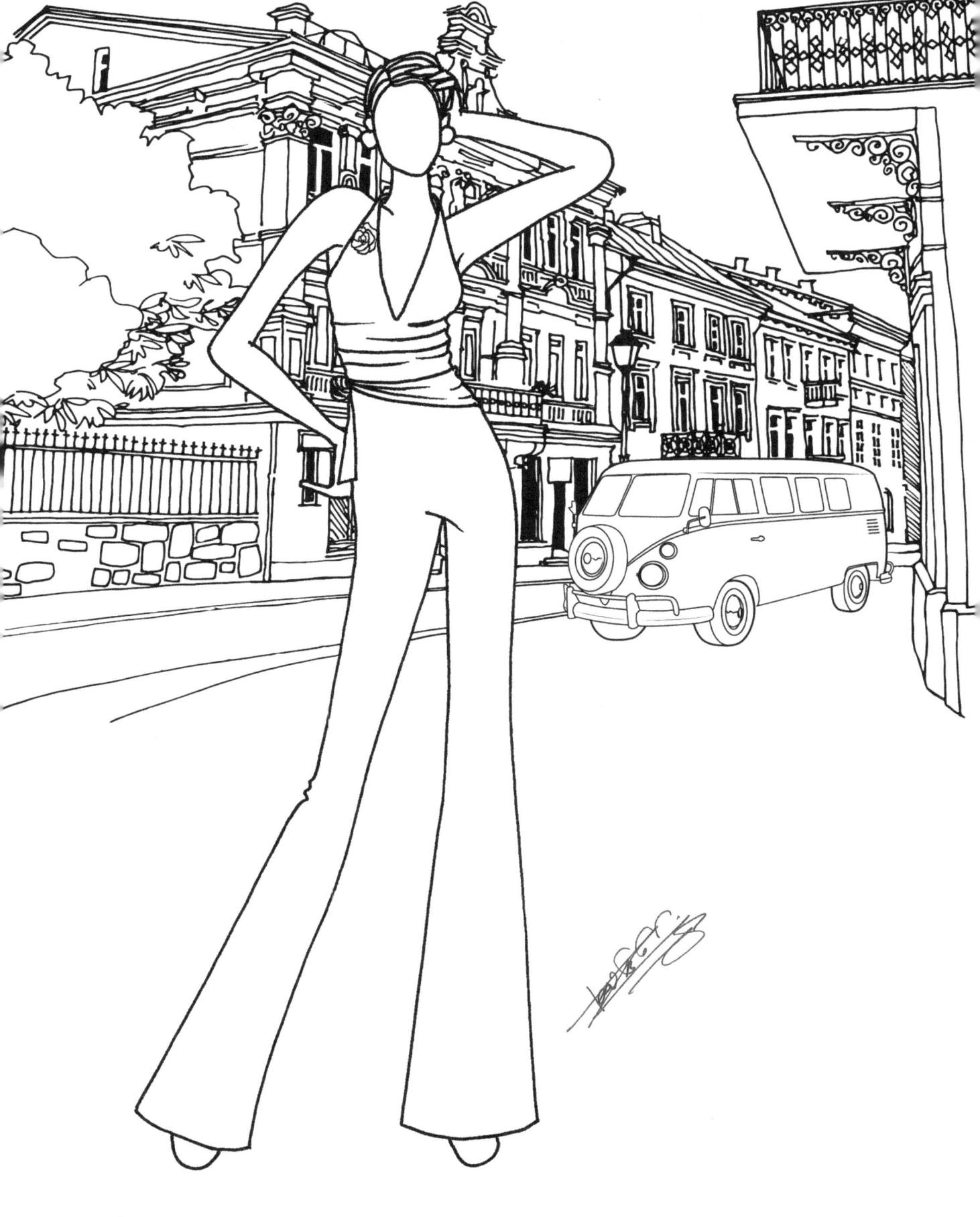

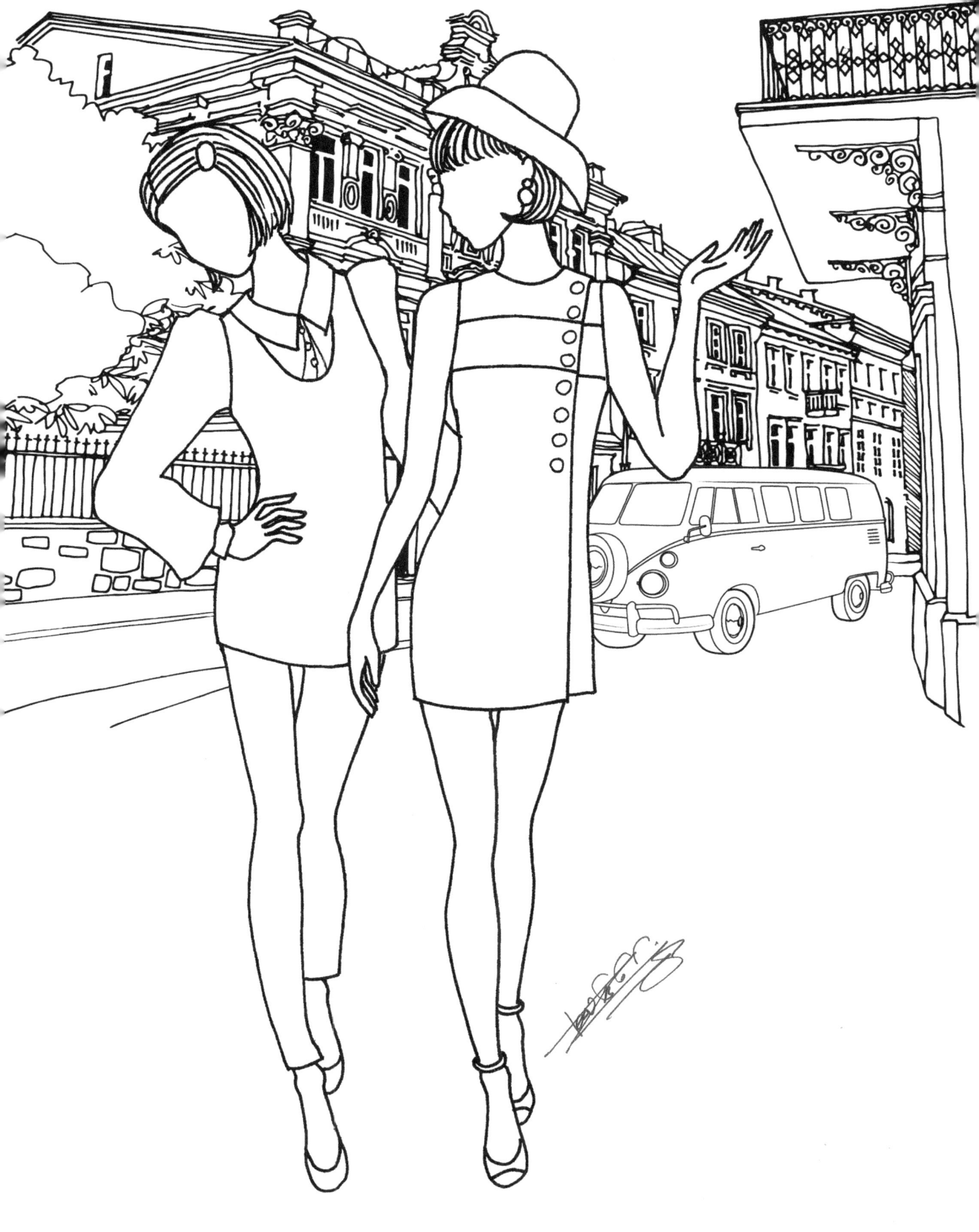

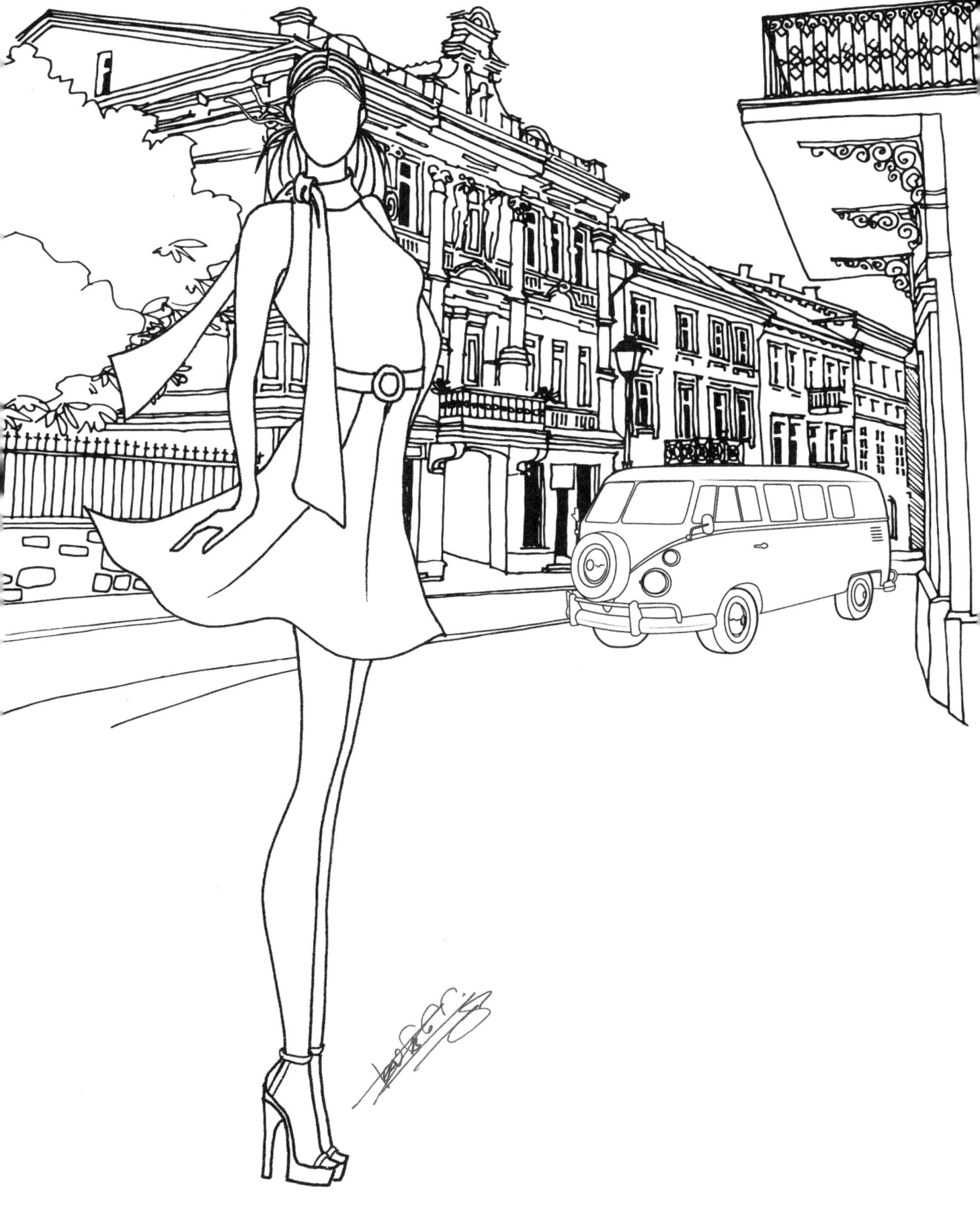

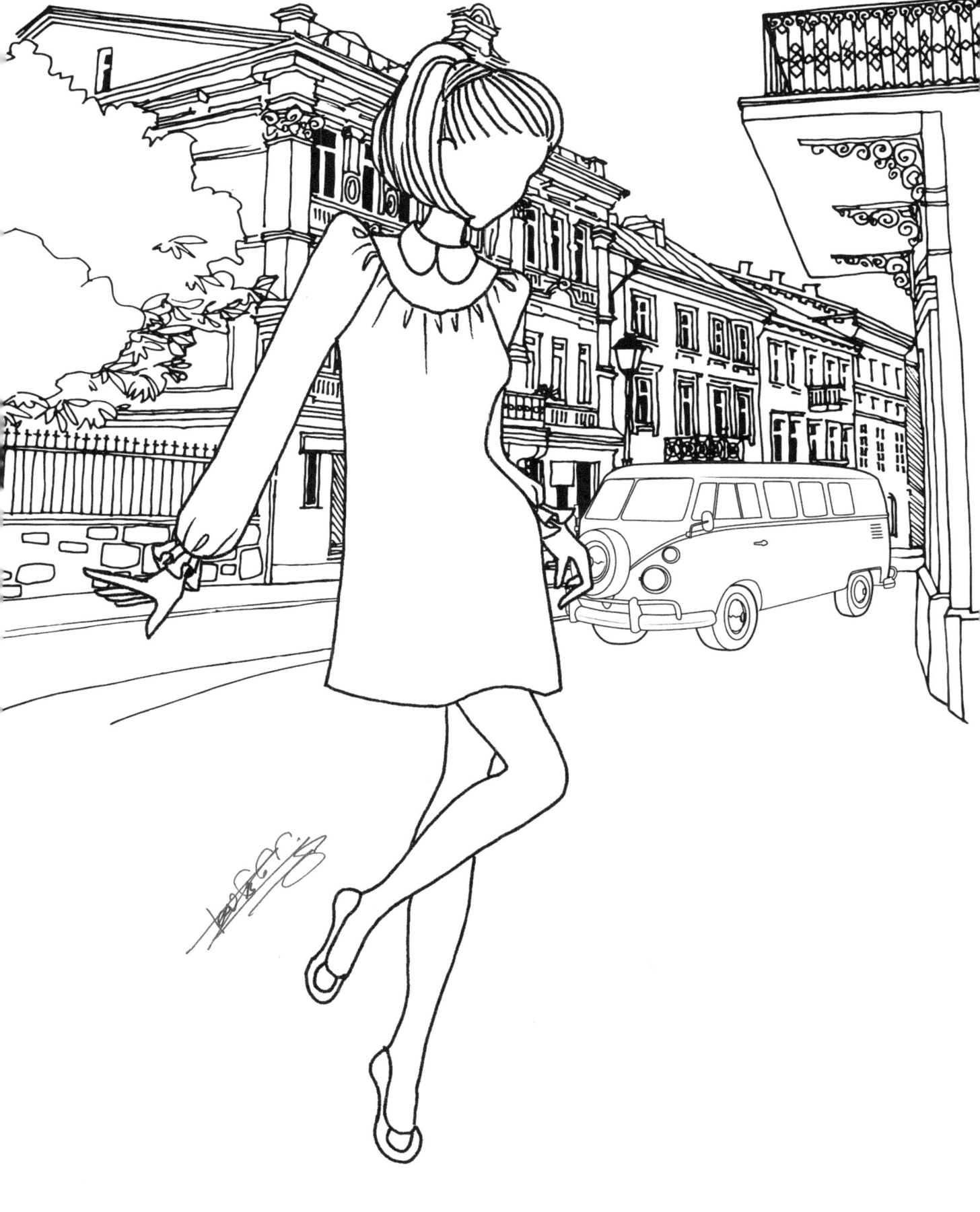

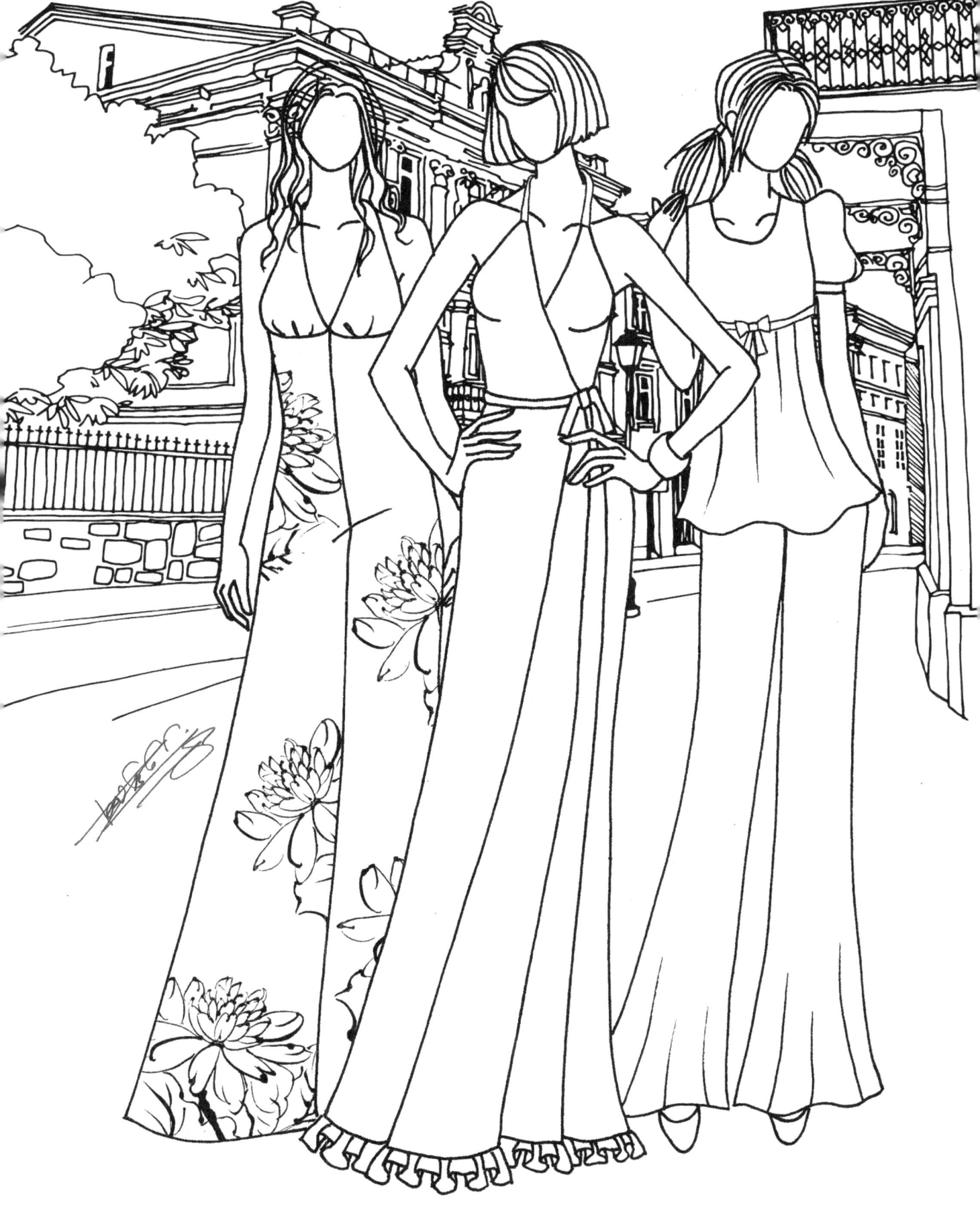

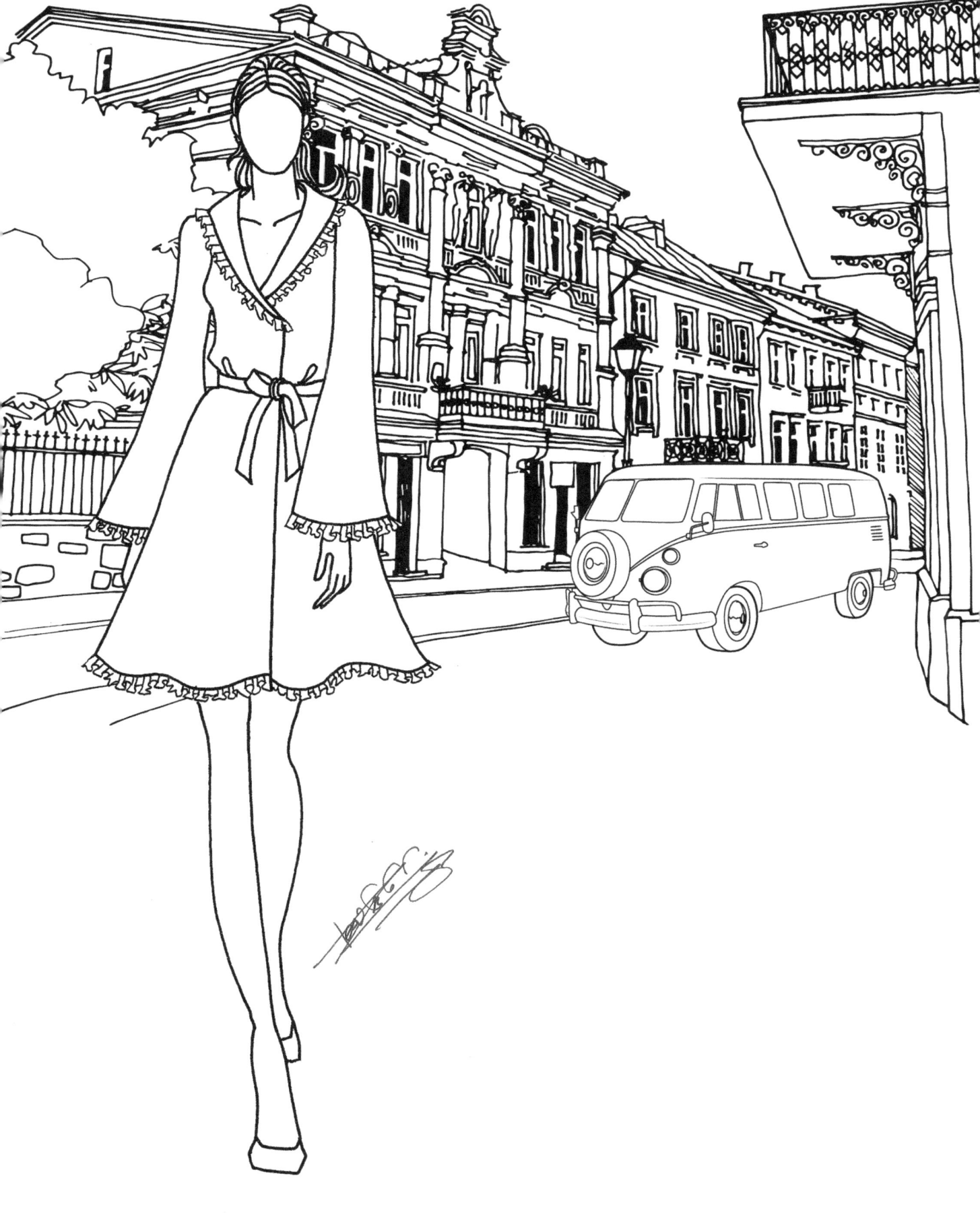

www.ingramcontent.com/pod-product-compliance
Lightning Source LLC
Chambersburg PA
CBHW080624220526

45466CB00010B/3451